BEARD

BEARD

PHOTOGRAPHS BY
MATTHEW RAINWATERS

CHRONICLE BOOKS
SAN FRANCISCO

Copyright © 2011 by Matthew Rainwaters

All rights reserved. No part of this book may be
reproduced in any form without written permission
from the publisher.

Library of Congress Cataloging-in-Publication Data is available.

ISBN: 978-1-4521-0165-1

Manufactured in China

Designed by Shannon Losorelli

World Beard and Moustache Championships is a registered
trademark of World Beard and Moustache Championships, LLC.

10 9 8 7 6 5 4 3

Chronicle Books
680 Second Street
San Francisco, California 94107
www.chroniclebooks.com

This book is dedicated to my parents and grandparents, who have always supported me even when they may not have understood me.

TABLE OF
CONTENTS

INTRODUCTION

———— MATTHEW RAINWATERS ————

IN THE SPRING OF 2007 I FOUND MYSELF QUITTING MY JOB
in the middle of a teachers' meeting. I had taught photography
for three years in a Los Angeles high school, and I was done
with it. A few months later I was living in Austin, Texas, putting
together a portfolio and trying to restart my career as a photog-
rapher. That's when I met Craig Steckbeck, a bearded and burly
graphic designer working for an upstart bottled tea company.

I found out Craig had just won a local beard contest and was
planning to shave his face due to the intense summer heat. So I
made a portrait of him and then told him about an international
beard contest I'd heard about taking place in Alaska in two years'
time. It was perfect: He could compete in a world class compe-
tition, and I could experience the majesty of Alaska. The only
catch—Craig couldn't shave his beard for the next two years.

So that's how we found ourselves, two years later, at the 2009
World Beard and Moustache Championships in Anchorage,
Alaska. The scene was unreal. Huge mountains hugged the city
from all sides, and crazy-looking hirsute men flooded the streets
and bars downtown. There was an odd mixture of competition
and camaraderie: these men had grown and cultivated their facial
hair—to excess—for most of their lives and they were fiercely
committed to the art of grooming.

The day before the competition featured a beard parade, the
obligatory press meetings, and a drunken happy hour at the

event center. But tensions were also running high. I witnessed an intense debate about the location of the next world championships. Dozens of different accents, all offering an opinion, are fairly hard to follow, but I think I understood that the European contingent wanted the next battle to take place in Europe, while the American team wanted it in Australia. I had no idea that beard growers could be so opinionated and passionate.

The day of the event came, and the veteran competitors arrived in elaborate period costumes that matched their faces perfectly; some had replica guns in their belts, others masterfully carved pipes in their mouths, whale harpoons in hand, or, of course, lederhosen. The rookies looked more thrown together—good enough to get them in the door but not up to the caliber of most of these men. As round after round of judging came and went, the competitors headed toward the bar and then stumbled into the room where I'd set up my light and camera.

It makes my job easy when everywhere I look there is another striking personality willing to have his photo taken. For me it was important to document these guys in the most honest way I could. I am aware the subject itself is a little kitschy, and I didn't want the photos to be the same. I had to shoot them in a style that didn't embellish the characters they had invented for themselves; their facial hair did a pretty good job of that. To do this I used a light that didn't create any shadows on the face. When they were in front of the camera I asked them to relax and clear their head, and then in most cases I made mug shots in which the hair became the sole subject.

The result is a catalog of this strange and unusual culture of men, united the world over through their primitive yet elaborate grooming techniques. A book of beards.

JACK PASSION San Francisco, CA
NATURAL FULL BEARD | 1ST PLACE WINNER
3RD PLACE OVERALL WINNER

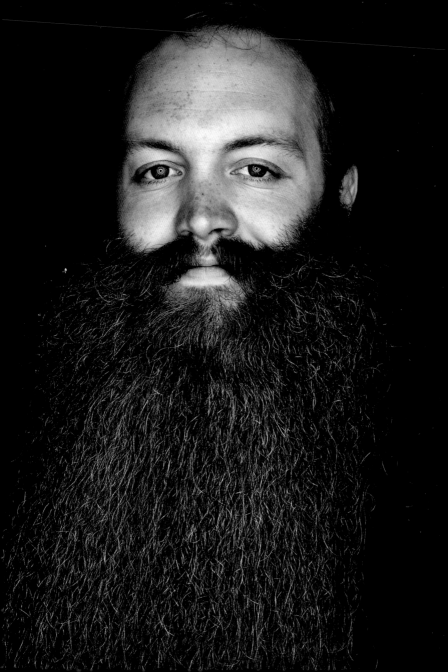

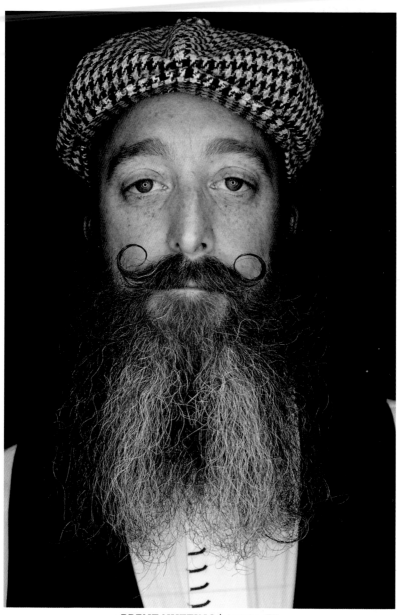

BRENT NUTTING | Austin, TX

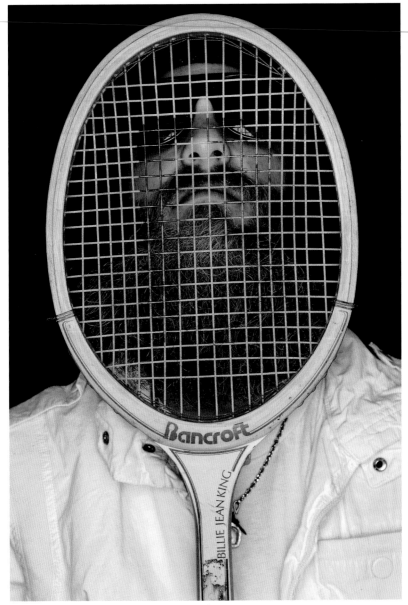

BRETT SCHMITZ | Granite Falls, WA

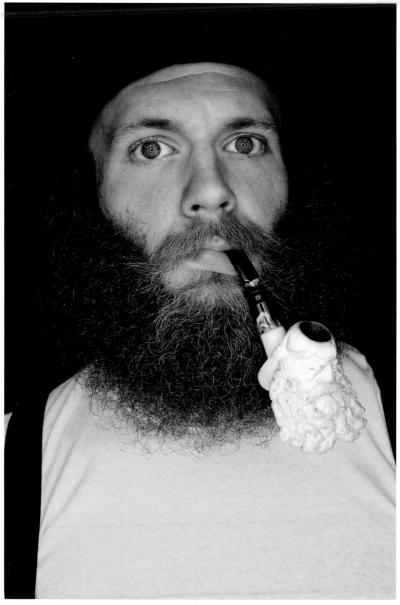

DEVIN CARA | Springfield, MO

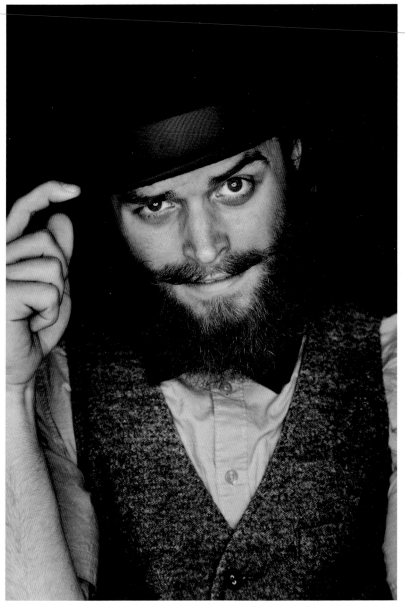

RYAN HOPPE | Detroit, MI

STUART WILF Colorado Springs, CO
FREESTYLE PARTIAL BEARD | 1ST PLACE WINNER

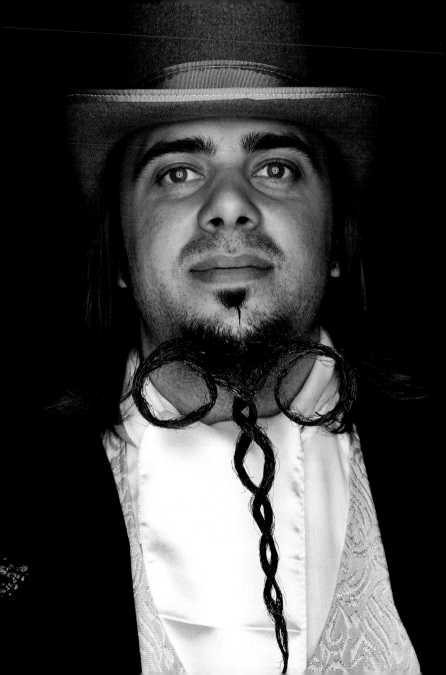

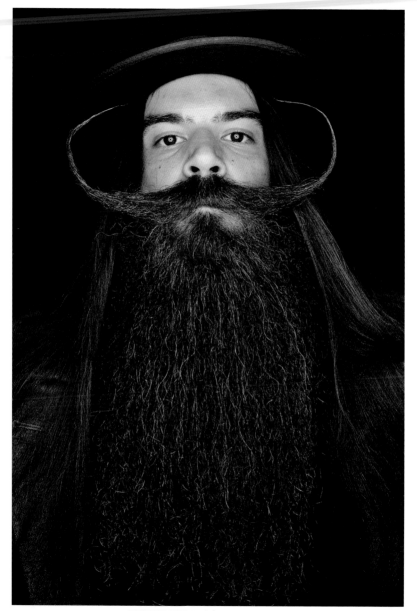

BURKE KENNY | Olympia, WA

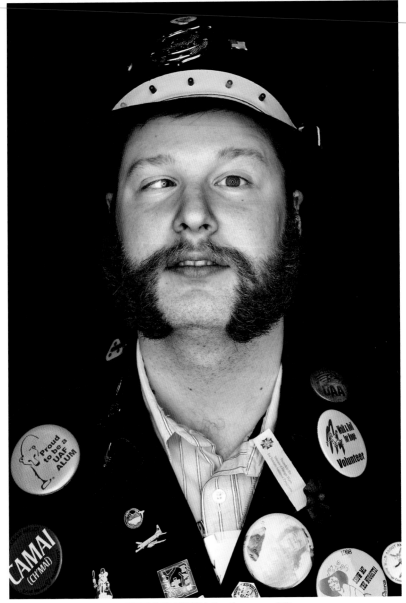

JAEDON AVEY | Anchorage, AK

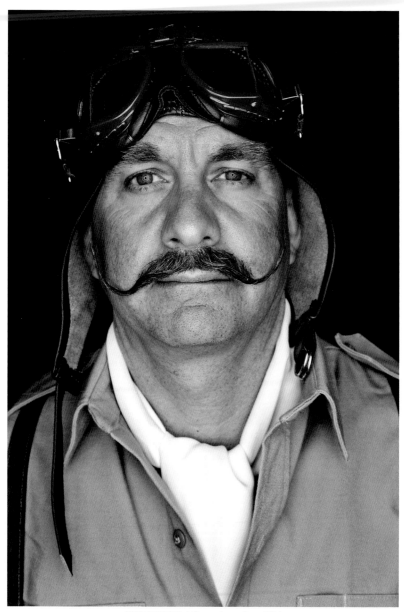

JEFF WELL | Port Angeles, WA

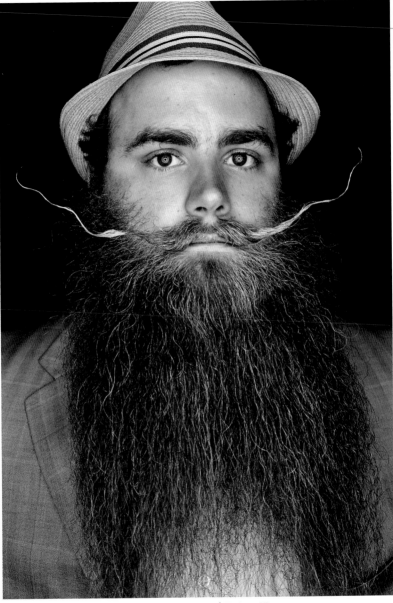

JEFF VIDOUREK | Boise, ID

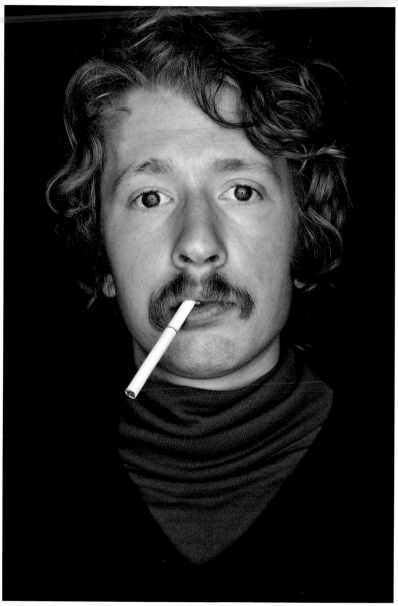

DANIEL SPERRY | Detroit, MI

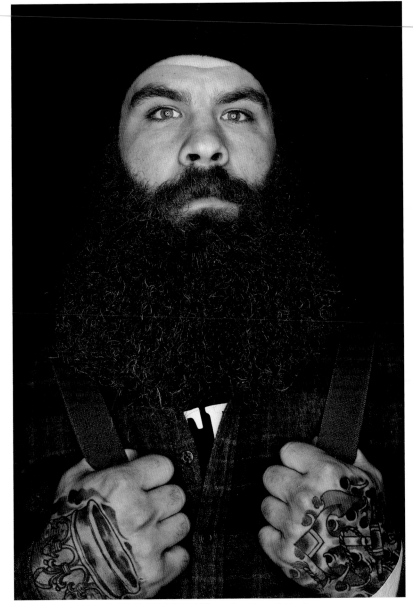

DAVID JANZEN | Thunder Bay, Ontario

JOHN PRICE Atlanta, GA
GARIBALDI FULL BEARD | 3RD PLACE WINNER

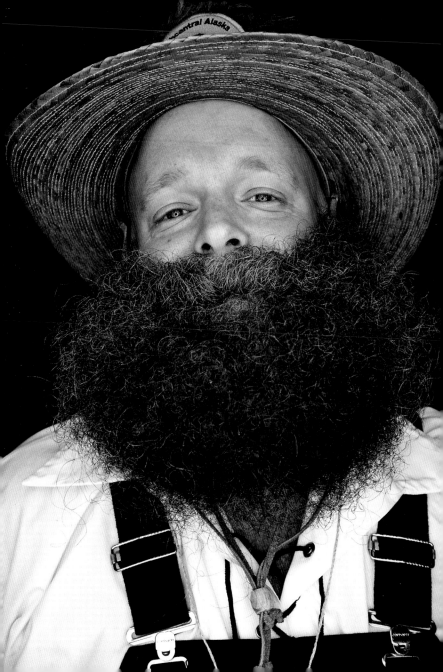

TO BEARD OR NOT TO BEARD— IT'S NOT A QUESTION

JOHN PRICE

WALKING OFF THE PLANE IN ANCHORAGE, ALASKA, TO attend and compete in the world's most formidable and renowned beard competition was truly an amazing, real/surreal, once-in-a-lifetime adventure. The two years of not having to shave twice daily (some say it's a curse), learning what foods to avoid in public (hot dogs, rice, and ice cream cones top my list), figuring out a way to exploit vanity and über-profic facial-follicle genes (thank you, Mom and Dad!), and raising money for the best foundation ever (working with kids stricken with cancer, for which I feel honored to be a volunteer), are memorable highlights of my precompetition "training" time.

Having no expectations placed on the competition phase of my experience other than a fun weekend meeting all the magnificent beards (and the men behind them) coming from all parts of the world, drinking draft beer through a straw, and promoting peace through facial hair, I was taken aback at how seriously many people take this competition and how chin-pube politics coupled with a bit of beard envy provided for a "best in show" vibe throughout this prestigious competition. When the talk turned to if I had or was considering sponsors, product endorsements, and costume designers, though totally flattered to be asked, it left me wondering how something almost completely determined by your gene pool (some of us are just a bit more

chlorinated than others) and choice of styling ended up a sport for profit. Maybe its becoming a sport for amateurs would ease my fear of seeing myself as a beardlete on the World Beardathalon Broadcast on ESPN.

Politics, beard envy, and the seriousness aside, the fun aspect, meeting and hanging out with some great beards, was intoxicating. Meeting my whiskers mates and getting to know the men behind all that hair: I cherish. Meeting Mr. Harvard and Mr. Canada and forming the Garibaldi Boys, coining ourselves the "GBS," and the stage mayhem that followed was utterly delightful.

While on that raised beard-walk, looking like a deer trapped in headlights, moseying right past the judges without stopping for proper inspection (nerves, I reckon), I somehow (must have been my beard drag!) placed third in my chosen-the-day-before-by-people-in-the-know category of Garibaldi and was thrilled to stand next to the two amazing Alaskan beards taking first and second. How cool!

Postcompetition, I thought about how everyone on the planet should have his or her "moment in the sun," as we say here in the South. That particular weekend was definitely mine. Famous for a weekend! Never did I tire of all the minutes of primping, picking, and poofing for the many beard fans who asked about a hundred times to snap a photo with the fellow who grew the "beard hive" on his face. I truly felt like a star—amongst many—that weekend.

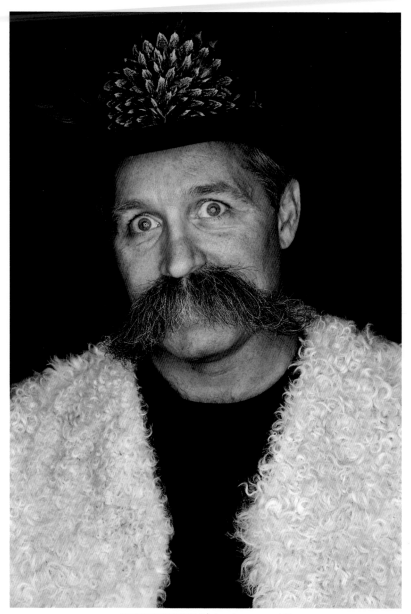

LYNDON HEIM | Anchorage, AK

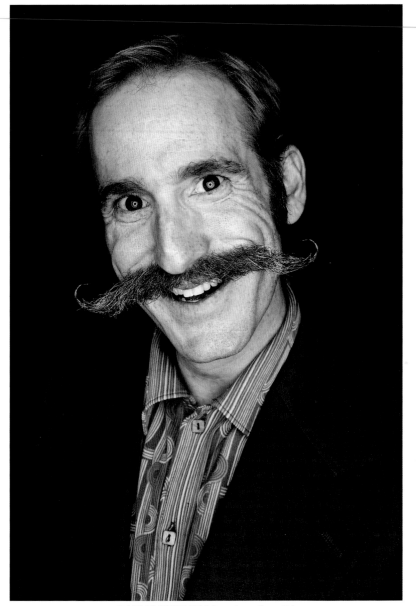

DAN ELDRIDGE | Los Angeles, CA

DEVON HOLCOMBE Jacksonville, FL
FREESTYLE MOUSTACHE | 2ND PLACE WINNER

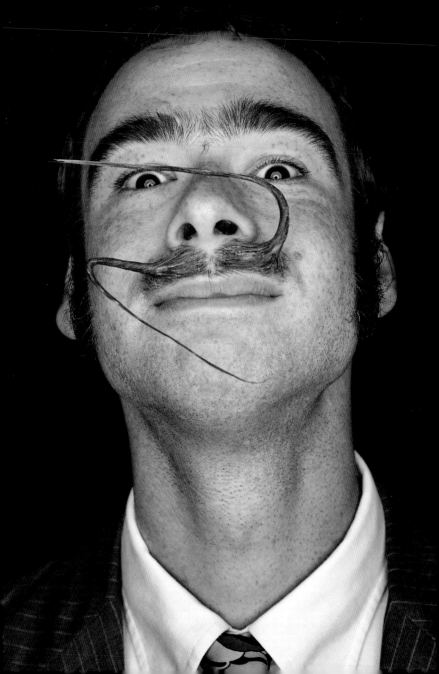

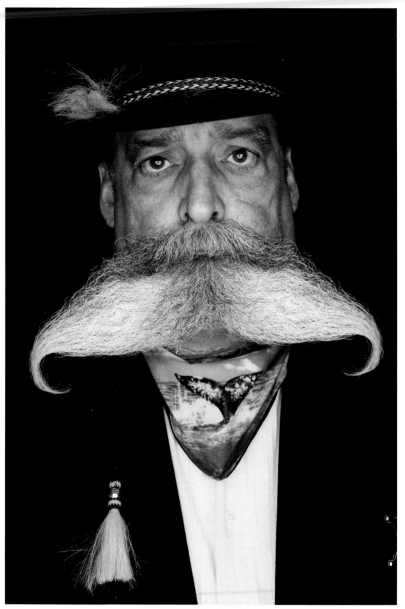

DAVID W. POWELL | Mt. Vernon, IN

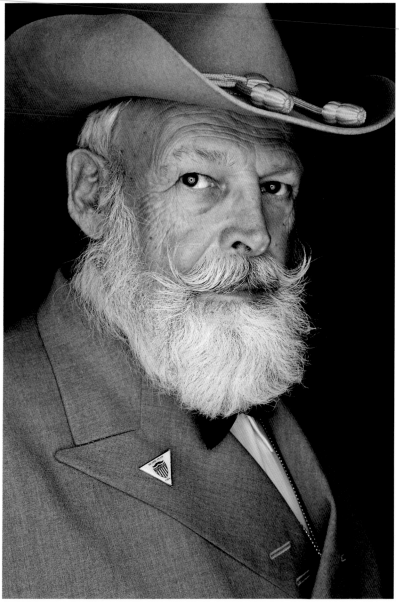

DENNIS DICKERSON | Woodbridge, VA

BILL MITCHELL Hinesville, GA
SIDEBURNS/MUTTONCHOPS | 3RD PLACE WINNER

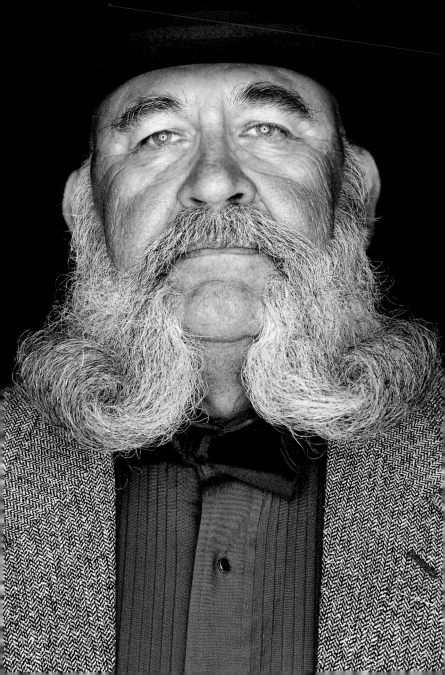

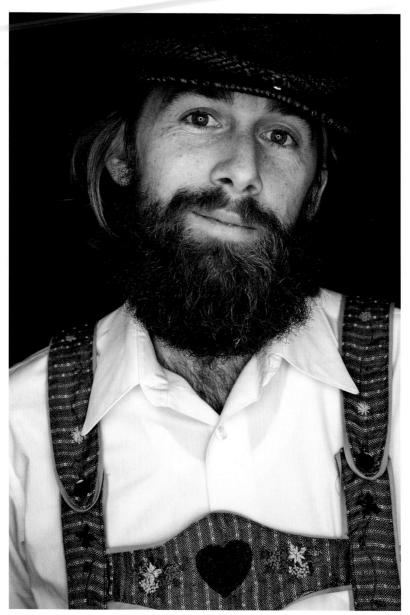

DREW DANBURRY | Highland, UT

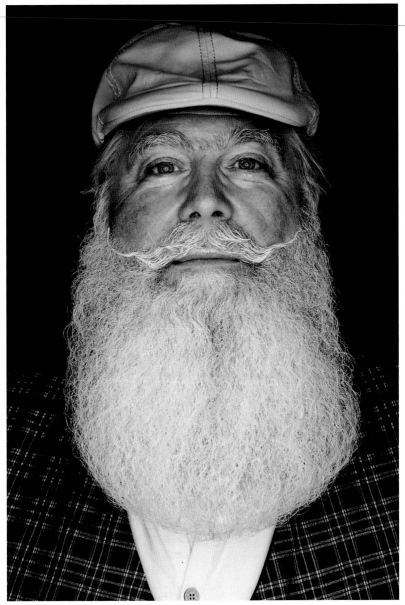

EDWARD ANGELBECK | Port Orchard, WA

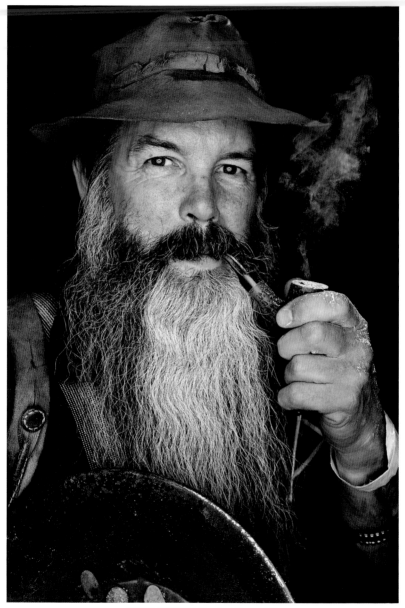

ERIC STICE | Eagle River, AK

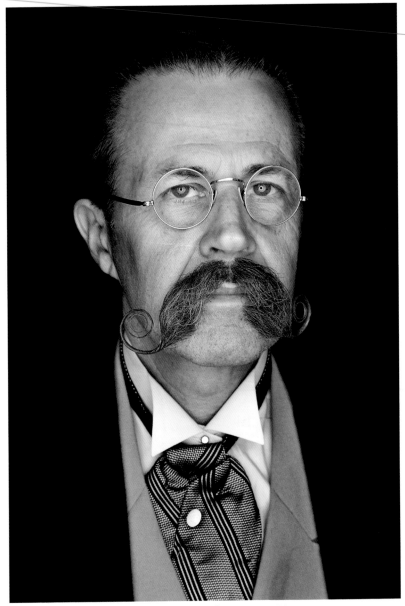

GARY W. HAGEN | San Jose, CA

UDO FRITZSCHE Konstanz, Germany
IMPERIAL PARTIAL BEARD | 2ND PLACE WINNER

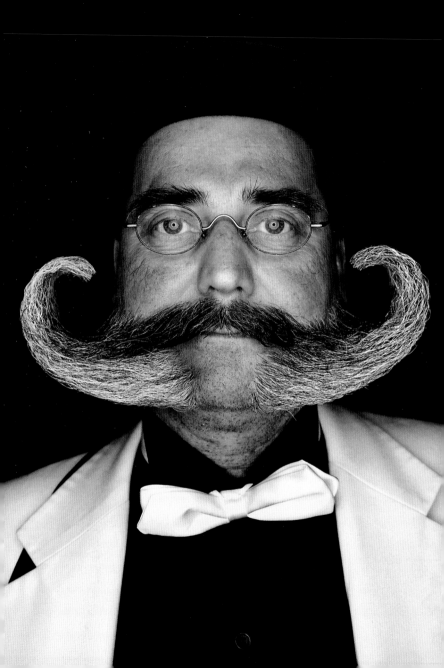

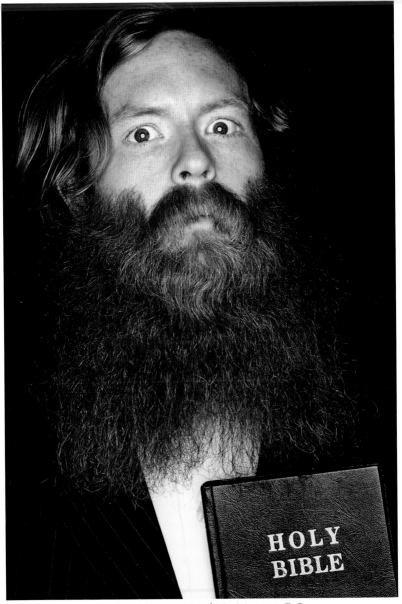

BRIAN HARRINGTON | Washington, D.C.

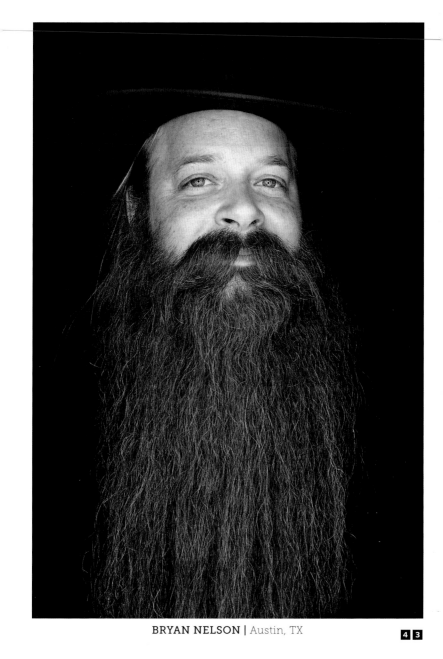

BRYAN NELSON | Austin, TX

MY REAL FACE

BRYAN NELSON

MY BEARD AND I HAVE BEEN FRIENDS SINCE 1990, THE YEAR
I graduated high school. We were forbidden to have beards or
moustaches in school, but we were permitted to grow sideburns
down to the bottom of our earlobes. Having pushed this rule
to the limit by having my sideburns down almost to my chin,
growing a beard seemed like a natural next step. I was ready to
let my follicles stretch past the small summer goatees that had
teased them in the past.

As this was my first real attempt, it started out very scraggly
and patchy, which made me a bit uncomfortable, but the reac-
tions and support of my friends kept me going. I remember in
particular that a good friend's youngest brother, twelve-year-old
Trevor, thought my beard was the coolest thing that had ever
happened in the history of the world. It's hard to deny support
like that!

I started a band and entered many skateboard competitions
during the next few years, with my beard filling in a little more
after every shave (which predictably coincided with job hunts,
employment often ending in shaving ultimatums). Eventually
I gravitated toward work that allowed me hirsute freedom, and
my beard's age started being counted in years instead of months.

Many habitual shavers ask about the negative aspects of hav-
ing a large beard. "Don't you get food in it all the time?," "Doesn't
it get caught on things?," "How do you kiss your girlfriend/wife?"

They don't ask about the vast benefits, such as when living in sketchy neighborhoods, even my fledgling beard made me feel safer and more intimidating as a man. Despite the fact that a beard would be a significant disadvantage in a brawl, it demands the kind of respect that helps to avoid a fight altogether.

I quickly noticed that my red beard was an easily identifable trademark for both arenas of skateboarding and music. For example, when I was tour-managing Japanese girl bands like Petty Booka and Tsu Shi Ma Mi Re, the girls needed very little English to find me by asking "Where?" and gesturing "beard" by stroking an imaginary beard past their chins.

I have not shaved since August of 2005. I often think of how free I would feel if I shaved. I like growing a beard, and starting fresh is nice every once in a while. But alas, I continue down the bearded path. It feels like the right way to go. I think that your face is not your real face if you shave every day.

JEREM FELTMAN Kenai, AK
ALASKA WHALER PARTIAL | 1ST PLACE WINNER

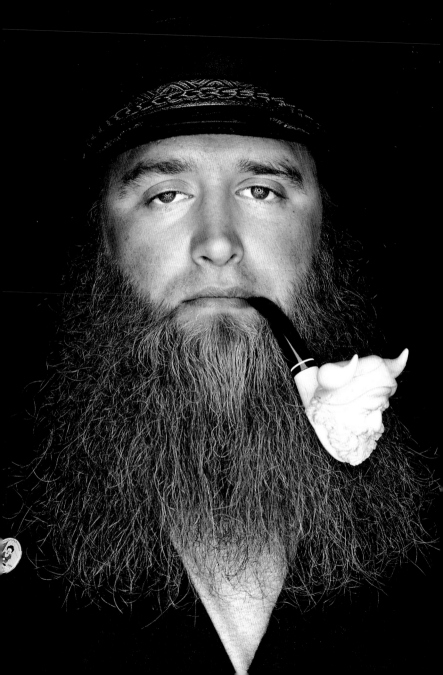

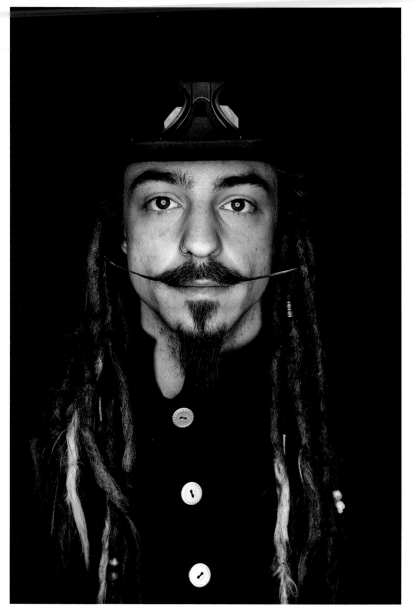

BRANDON NANCE | Grosse Ile, MI

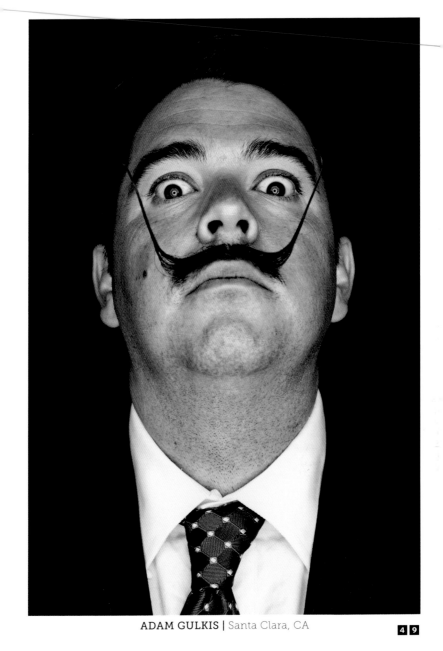

ADAM GULKIS | Santa Clara, CA

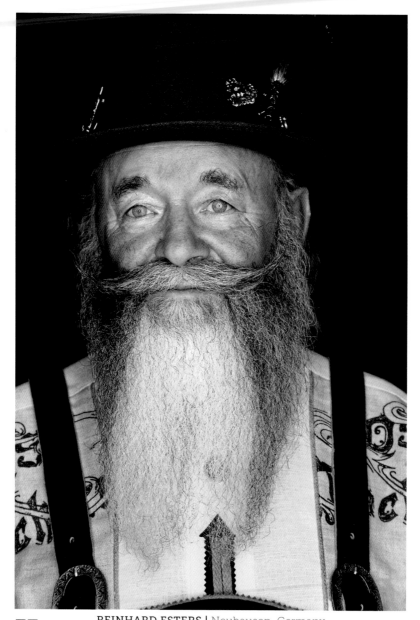

REINHARD ESTERS | Neubausen, Germany

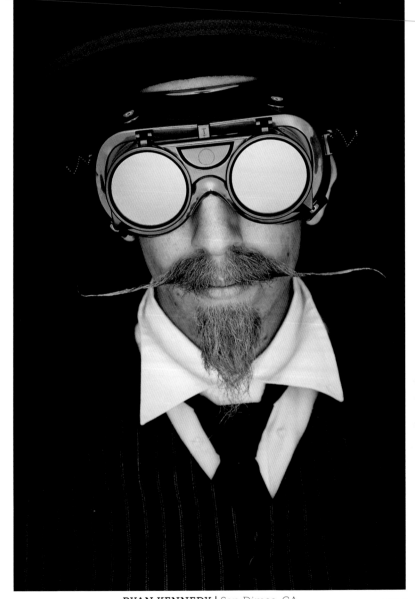

RYAN KENNEDY | San Dimas, CA

BREMAN GROVE Evansville, IN

NATURAL GOATEE | 2ND PLACE WINNER

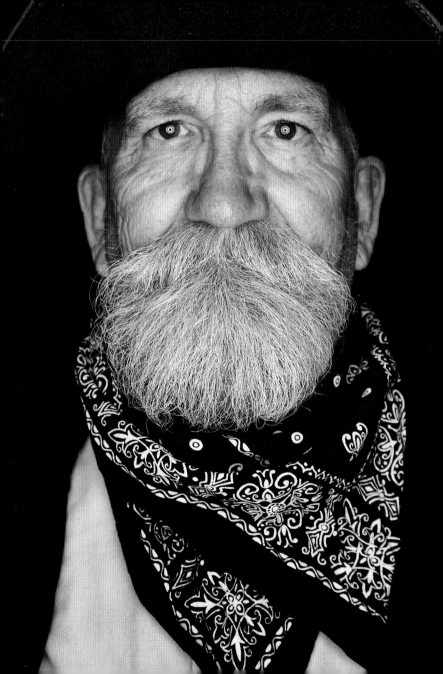

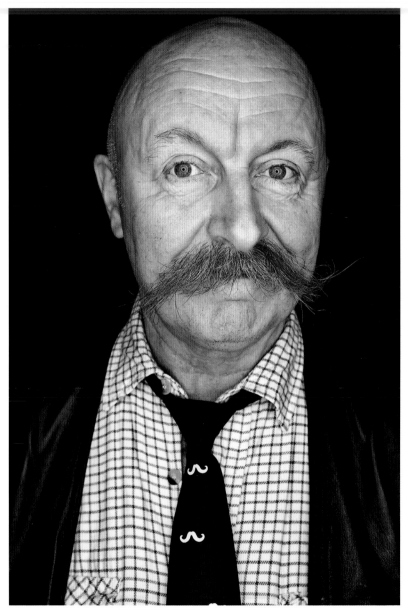

JOCK BLAKEY | London, England

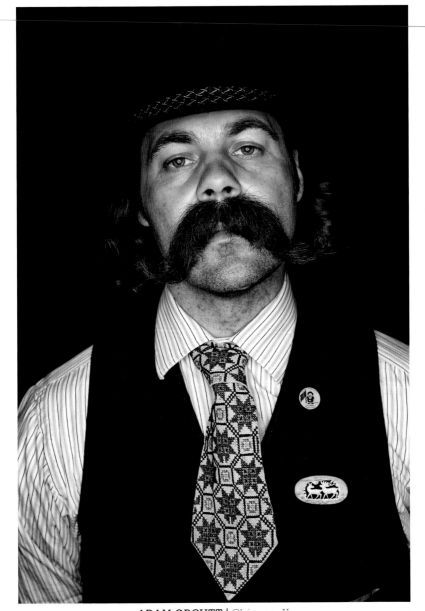

ADAM ORCUTT | Chicago, IL

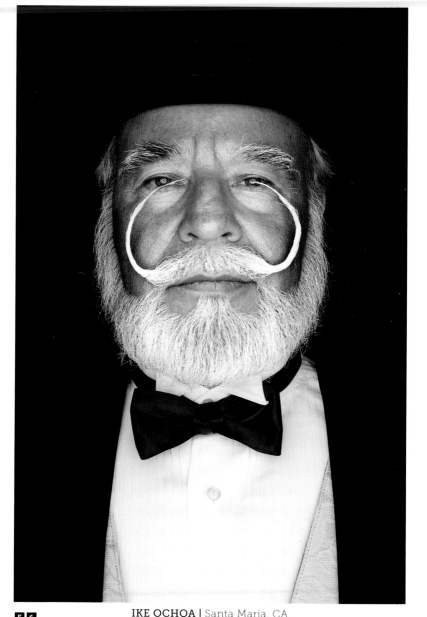

IKE OCHOA | Santa Maria, CA

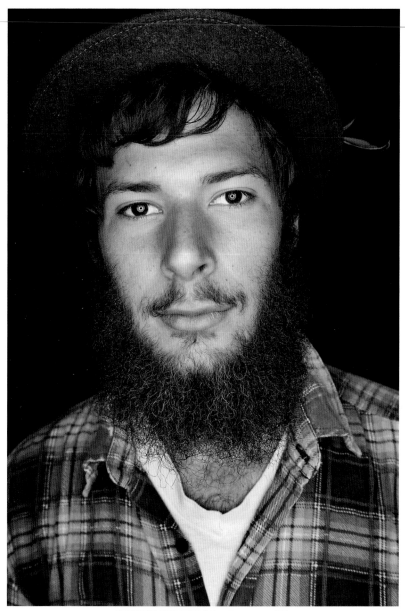

BRENT MILLER | Anchorage, AK

BEN DAVIDSON Ridley Park, PA
NATURAL MOUSTACHE | 3RD PLACE WINNER

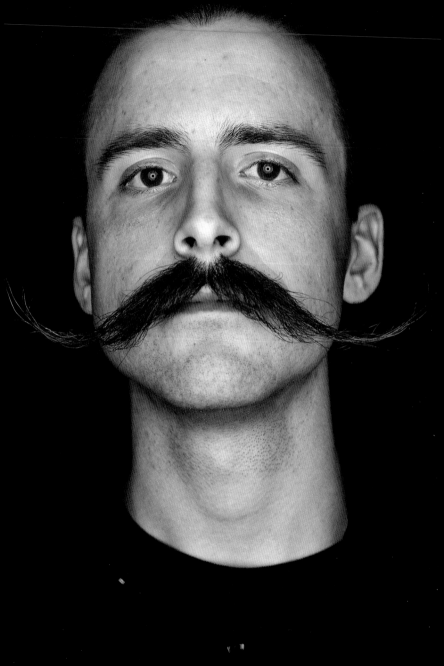

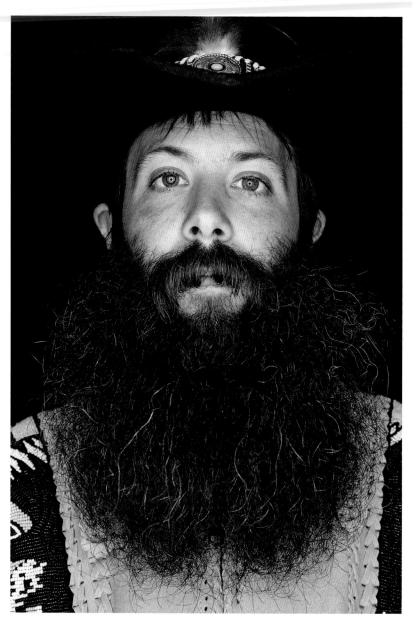

CORY PLUMP | Austin, TX

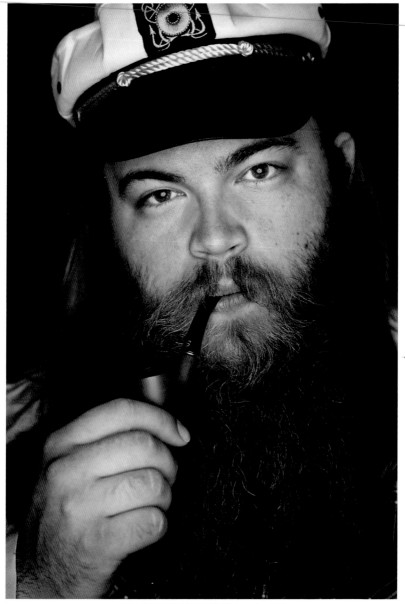

CRAIG STECKBECK | Austin, TX

THE MOOSE WHISKERER

CRAIG STECKBECK

I DON'T KNOW WHEN MY FASCINATION WITH BEARDS AND moustaches started. I've had facial hair of one configuration or another for as long as I can remember—probably for as long as I could grow one. Someone once told me that my beard was a mask, that any guy who feels the need to cover up his face must have something to hide. I suggested that she might have an embarrassing tattoo on her scalp.

I started growing the beard that became my Alaska beard with no aspirations. In the summer of 2007, I got a great job at Sweet Leaf Tea. Their office is the kind of place where you're expected to wear flip-flops and bring your dog to work. It's exactly the sort of company where you can get away with growing a ridiculous beard. I assumed it was the last chance the real world would give me, so I maintained what I would describe as a full but well-groomed beard. I even broke the ice with my new coworkers by giving all the girls fake moustaches.

About the time I was starting to think about trimming it off, I met Matthew Rainwaters at a photo studio he shares with a mutual friend. The beard became a topic of conversation. Matt snapped some test photos and demanded, "Whatever you do, don't shave until we talk again." A few days later, I was back at the studio. He pulled out my test shots and said, "You should keep growing your beard, and we'll fly to Anchorage for the

World Beard and Moustache Championships in May '09." It was the sort of dare that someone makes or accepts without really thinking about it.

I'm not sure when we started taking this dare seriously, but I stopped trimming my beard altogether. Before I knew it, there was no doubt in my mind that we were taking this trip. It didn't seem very spontaneous at the time. After all, the event was almost two years away. On the other hand, I had just agreed to travel over three thousand miles with a guy I had known for less than a week. Looking back, it's one of the least rational things I've ever done in my life.

I was an amateur in the relative scope of things. I felt like a sheep in wolves' clothing. There were people in that room who'd devoted their lives to facial hair. People ask me if I'm disappointed that I didn't win anything. The truth is that I grew the beard to go to Alaska, but I never went to Alaska to win a beard contest. The beard was my ticket to get in the door and bear witness to this festival of wonderful absurdity. In that, I consider the trip a wild success.

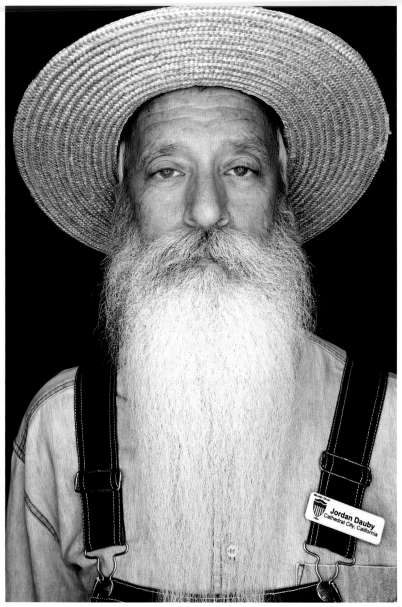

JORDAN DAUBY | Cathedral City, CA

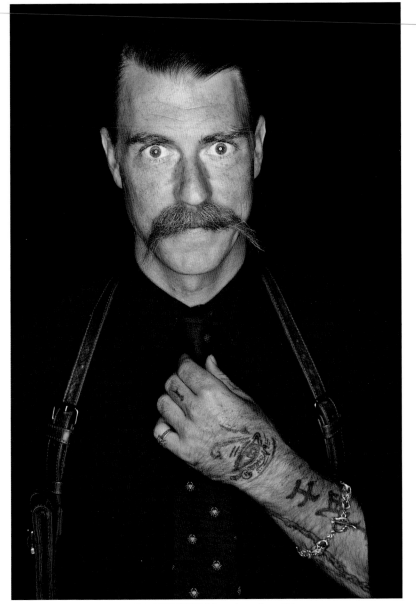

JOSH SPENCER | Los Angeles, CA

MARKUS BROSS Schomberg, Germany
VERDI FULL BEARD | 2ND PLACE WINNER

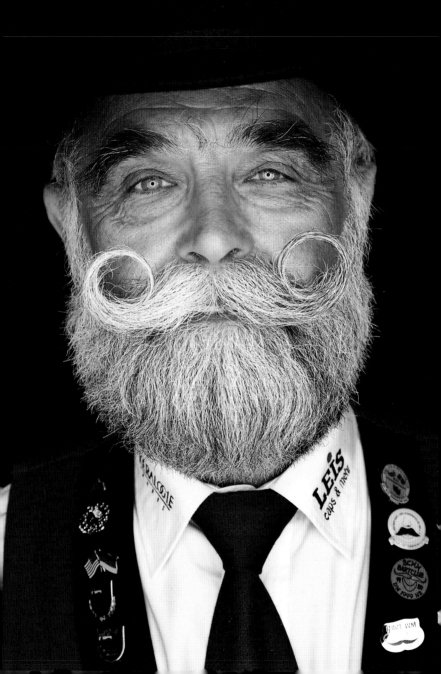

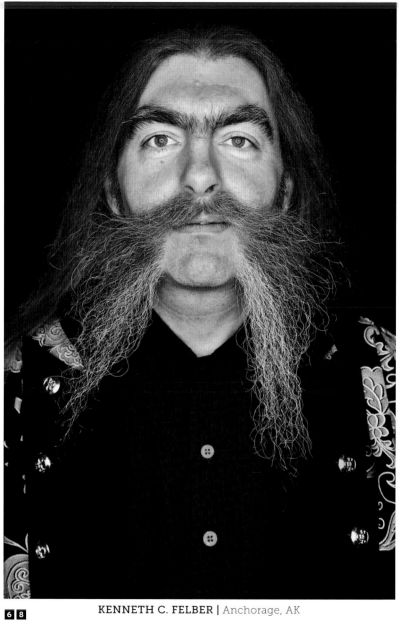

KENNETH C. FELBER | Anchorage, AK

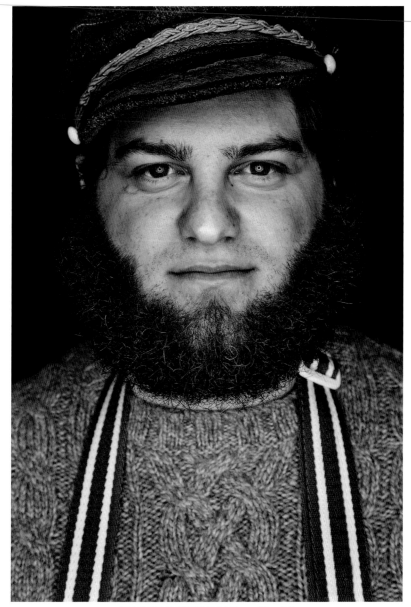

MAX ZIMMERMAN | Danville, CA

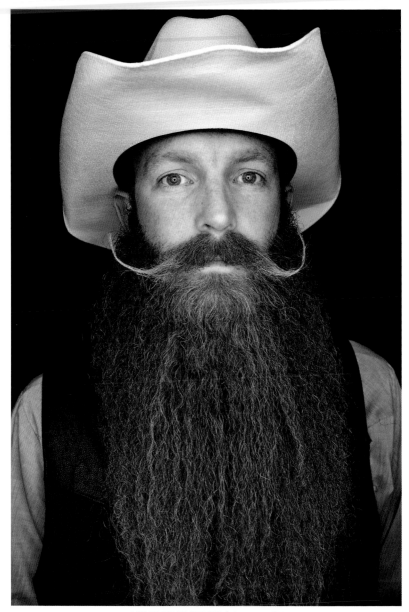

ALLEN DEMLING | Austin, TX

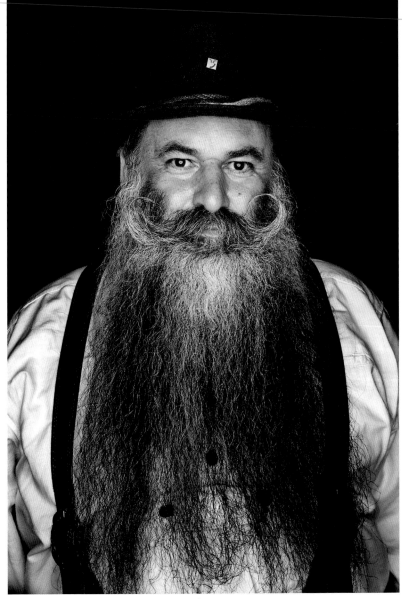

HANS HORST | Moos, Germany

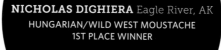

NICHOLAS DIGHIERA Eagle River, AK
HUNGARIAN/WILD WEST MOUSTACHE
1ST PLACE WINNER

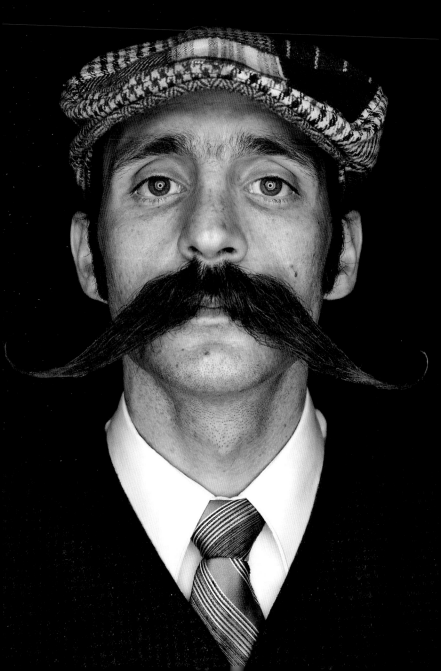

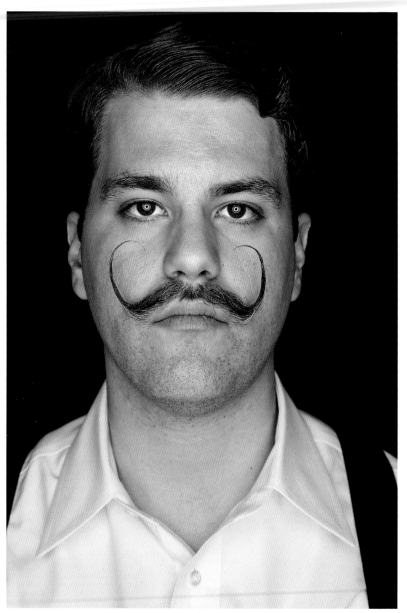

LEO LITOWICH | Grand Rapids, MI

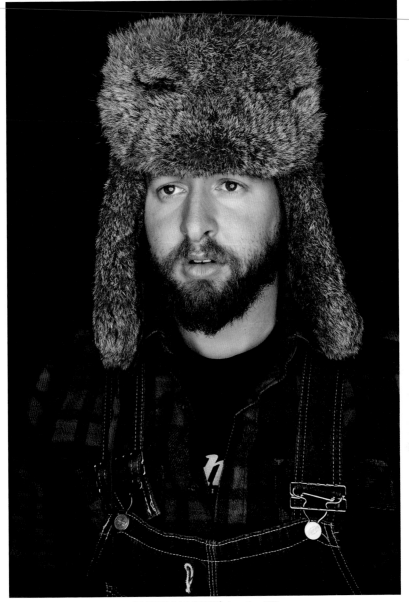

JAMES MOODY | Austin, TX

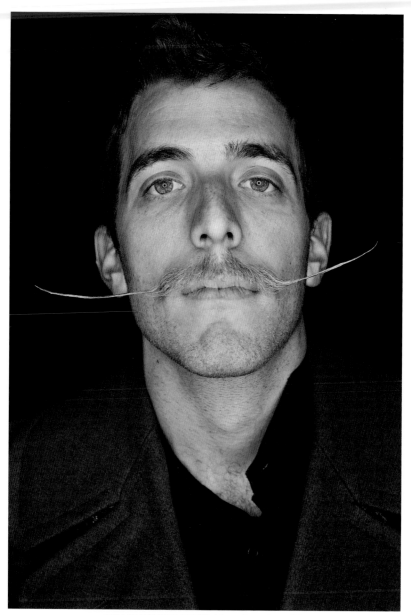

ADAM SCOTT PAUL | Los Angeles, CA

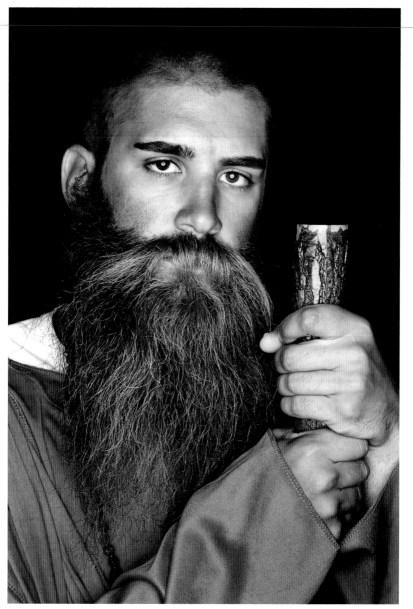

NICHOLAS STEVENS | Ashland, OH

PATRICK MELCHER Los Angeles, CA
IMPERIAL MOUSTACHE | 2ND PLACE WINNER

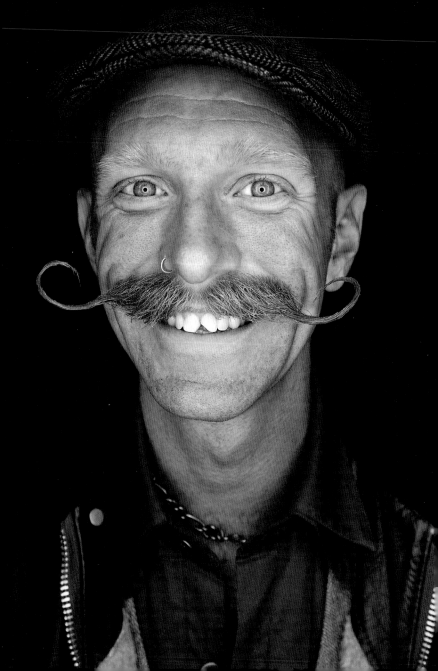

THE ASCENSION OF
THE IMPERIAL

PATRICK MELCHER

BEFORE THE WORLD BEARD AND MOUSTACHE CHAMPIONSHIPS,
I did my homework: studied the categories, looked into the
previous winners and reigning champions. I played with various
pomades, waxes, and even the soap charges that a good punk-
rocker should know. I had a good bit of confidence after my
beard club (the Bristly Chaps of Los Angeles) voted me most
likely to bring home a medal. I'd been growing this thing for two
years and was dying to give it a glorious sendoff with a shave
the day after the event.

We got there the day before the competition. All of the conten-
ders, former champions, and families of fans were trotting through
twenty blocks of downtown Anchorage while chanting, hollering,
and doing walking interviews for various news programs. If you've
never seen the parade of beards before, imagine St. Patrick's Day
without the green. Truly a sight to behold.

Pitted against sixty-year-old dudes with names like Günter
Rasmussen and Schani Mitterhauser, I was sure that I had no
chance. This was their life. Traveling the globe, styling up their
facial pubes, and repping it hard. These dudes had it all down to
a science. Decades of competitive bearding had given the Ger-
mans and Hungarians an identity, given the Russians even more
of a reason to be smug, and even gotten this one British dude on
a Wheaties box.

I was so nervous before the competition I had to pee every five minutes. And it was in the bathroom where a Gandalf clone leaned over to me and said, "I can't wait for this weekend to be over so I can lop about eight inches off this thing. Every morning I end up pissing all over the bottom half of it." I was too nervous to even be disgusted by the yellowish stains that had turned it into a two-tone chin windsock.

I sat through nine categories of moustaches and sideburns while sweating under spotlights and waiting for my turn in the Imperial category. I couldn't wait to take that long walk down the runway, lean over in front of the judges, and be inspected like some Irish setter for Best in Show. Fifty other dudes were in my category. Dudes who hold five-year trophies and dudes who have the genetics and breeding that have evolved specifically over millions of years for premium hair growth.

As I walked across the runway, I noticed that I was sandwiched between a guy who looked like a 1950s porn actor and a dude in a 1920s bodybuilder costume. The cool part of it all is that directly after everyone in your category has been seen, the judges have a meeting and announce the winners. You don't have to wait until the end of the whole event for the results, so it really is like beard Olympics. I guess all of my grooming paid off: They called my name and I won second place. I ran up on stage totally amazed. The thought of beating all these 'stache veterans was mind-blowing.

GERHARD KNAPP Pforzheim, Germany
FREESTYLE FULL BEARD | 2ND PLACE WINNER

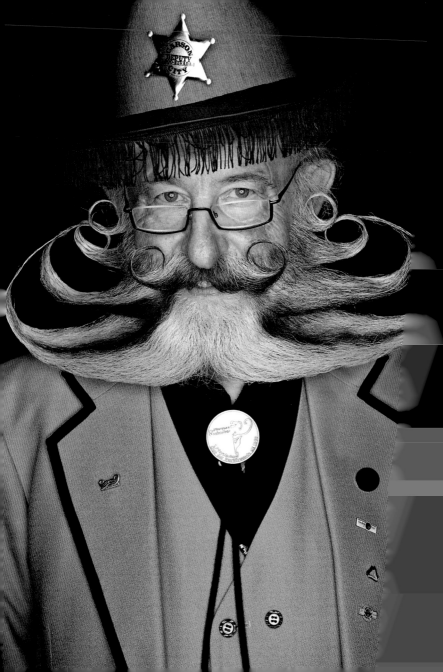

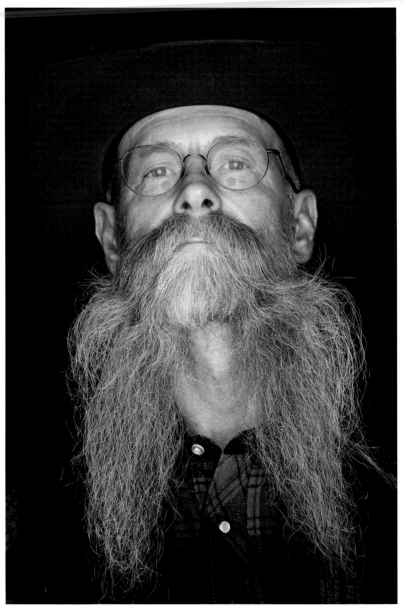

JAMES GALLAHER | Dayton, WA

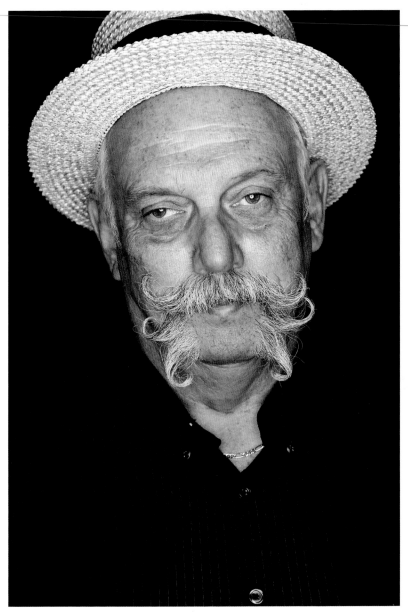

JEAN AMERICA | Zandhoven, Belgium

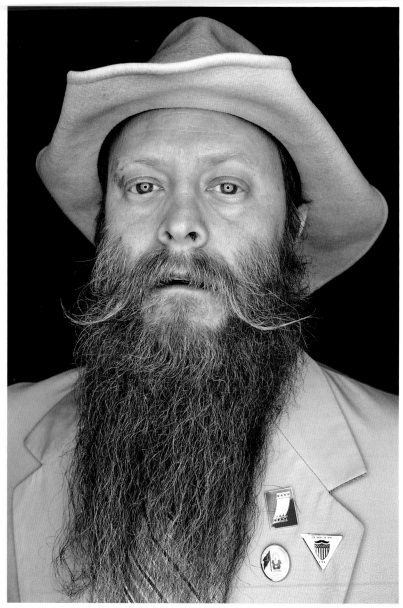

PAUL ROOF | Charleston, SC

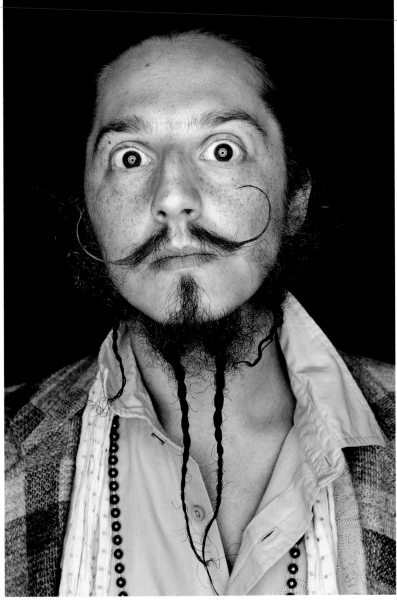

ALESSANDRO SICCO | Brescia, Italy

AARON SURING Juneau, AK
ALASKAN WHALER PARTIAL BEARD
2ND PLACE WINNER

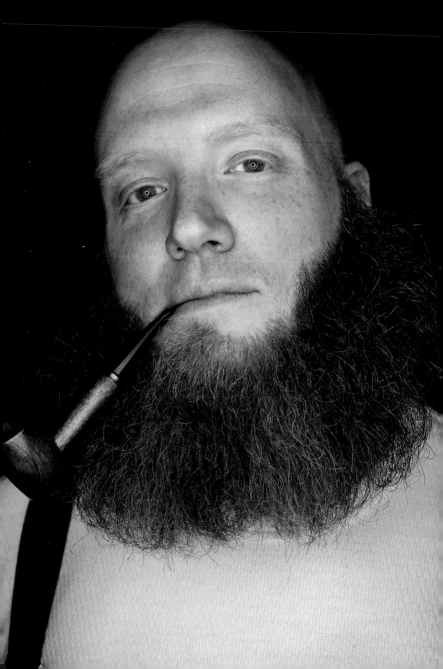

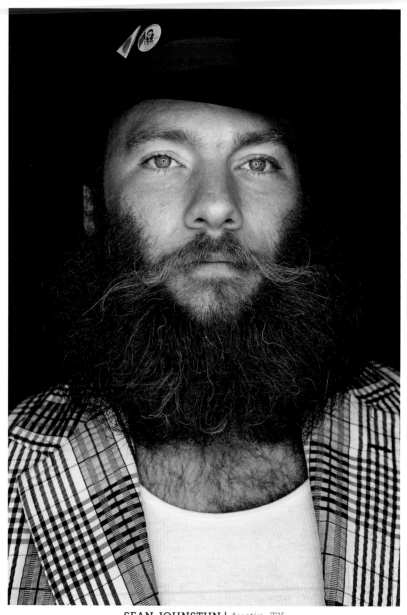

SEAN JOHNSTUN | Austin, TX

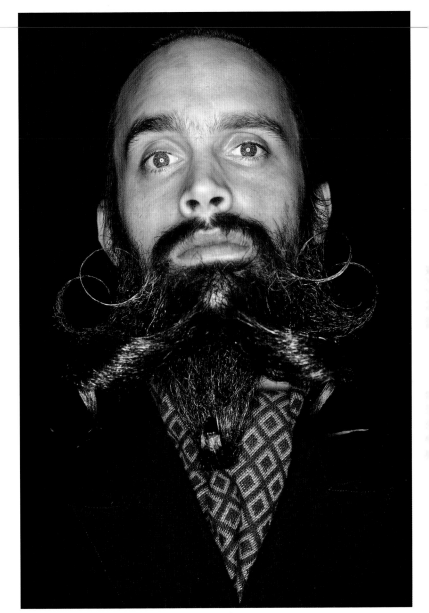

SHAWN KNIGHT | Ferndale, MI

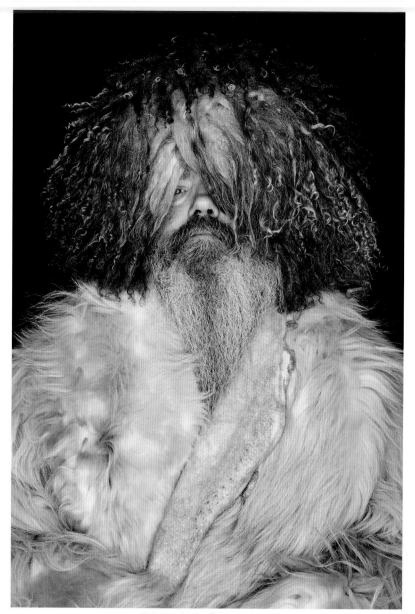

STEVE GLOS | Wasilla, AK

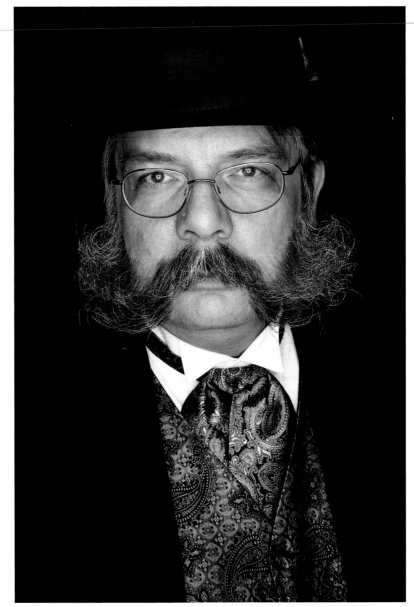

STEVEN CRISS | Beaverton, OR

KEES LEK De Kwakel, Netherlands
NATURAL MOUSTACHE | 1ST PLACE WINNER

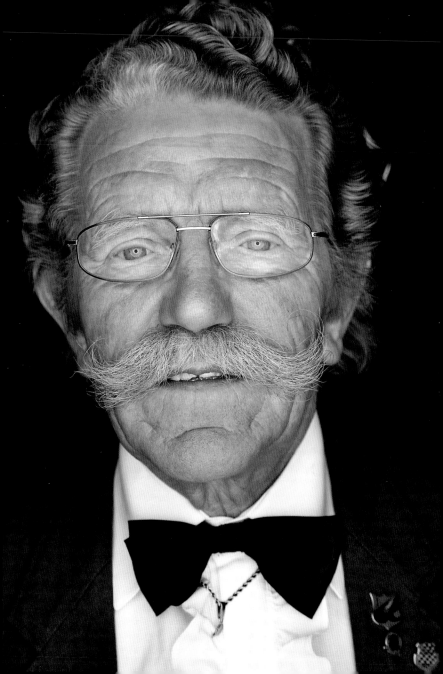

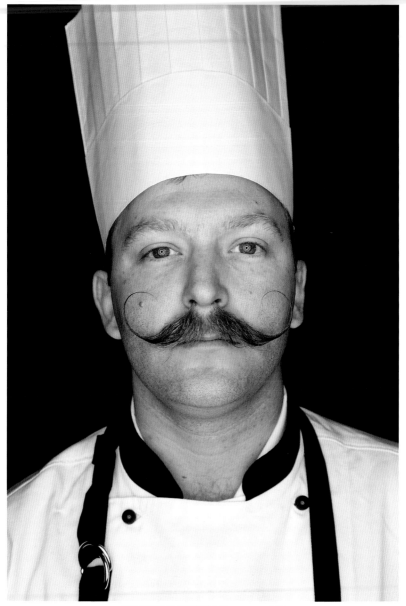

KENTEN MARIN | Houston, TX

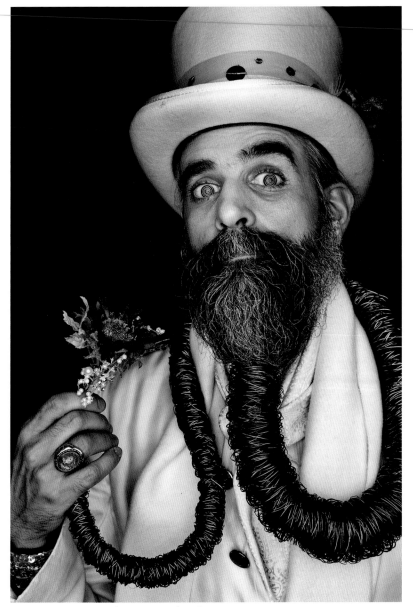

$TEVEN RA$PA | San Francisco, CA

PREPOSTERO SAYS BOING!

————————— $TEVEN RA$PA —————————

I AM NOT A COMPETITIVE PERSON. NOR AM I A FAN OF judging so much as celebrating what makes people unique, I didn't go to the World Beard and Moustache Championships in 2009 to compete. I went because it looked joyful. And because so many people insisted that with a beard like mine ("Prepostero"), I *had* to go. From afar the event looked welcoming, with images that invoked Santa Claus, Dr. Seuss, wizards, kindly grandfathers, and all manner of festively bearded, moustached, and festooned eccentricity. It promised to be an event that celebrated imagination, so I went to meet kindred spirits and share something of myself. This made it all the more disappointing for me and poor Prepostero when we were told the morning of the competition we could not participate.

What message does it send when a man who has professionals style his beard the morning of the competition may participate, but someone who has grown his beard for over a decade and sculpts it himself daily as a work of art may not?

Why was I excluded? That remains a subject of controversy and debate. Some said the American judges didn't want to offend the European founders and their rule book: wire is simply not an allowable "grooming aid" in the Freestyle category. Yet, I had received assurances the day before by a German founder of the Freestyle category that I would surely be allowed and that all manner of materials were permitted; he had created the category to be inclusive. I believe errors in judgment were made

and I can forgive them being a bit sloppy. But what I can't quite forgive or accept is that the organizers and participants took the competition so seriously that they lost their sense of humor and humanity. Consider that in order to compete in the Dalí moustache category the competitor's moustache must not rise above his eyebrows. Poppycock! Dalí's moustache certainly did rise above his eyebrows on many pleasant occasions, and he was an iconoclast who stood for breaking the rules of polite society. It is the spirit of the man and artist that should be honored—not a rule.

Since the championships I have urged the organizers to be inclusive: to allow as part of the Freestyle categories facial hair of every conceivable kind; to welcome bearded ladies and all manner of materials, including blinking, motion-activated, pyrotechnic, or beaming; and to embrace marvelous new technologies that don't yet exist. Or create a new category that is radically inclusive because I am confident it would become the most exciting and popular of all. The event has tremendous potential to nurture the human spirit, and I hope it will.

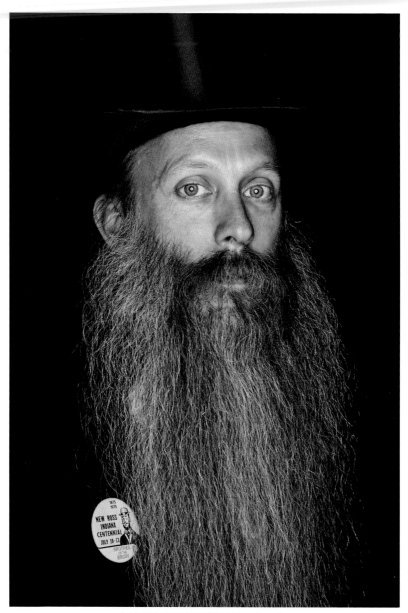

AARNE BIELEFELDT | Willits, CA

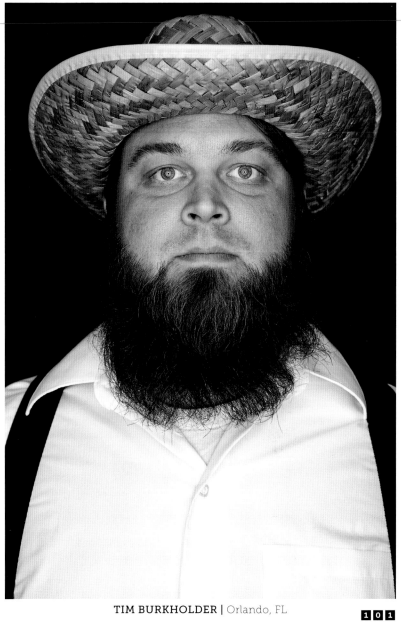

TIM BURKHOLDER | Orlando, FL

TOOT JOSLIN Tahoe City, CA
SIDEBURNS/MUTTONCHOPS | 1ST PLACE WINNER

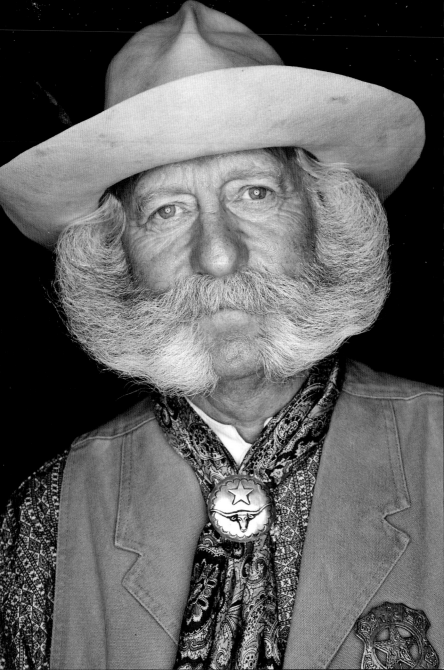

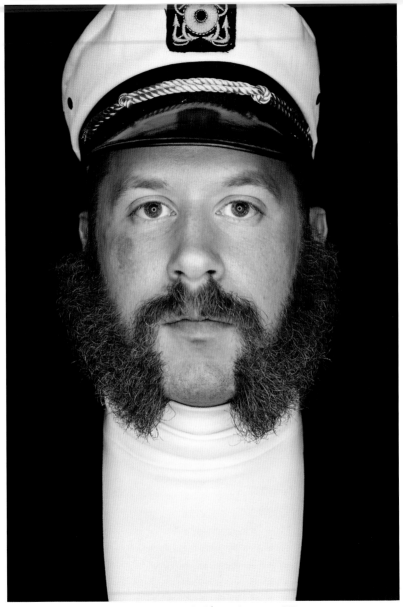

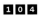

TIM MARTINSON | Anchorage, AK

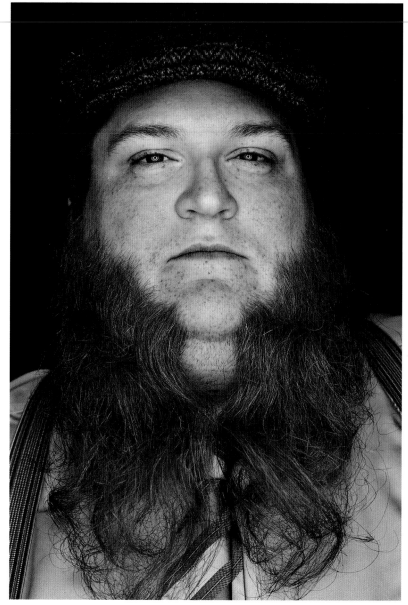

WARREN LILLIE | Winnipeg, Canada

EDDIE QUEIN | Charlotte, NC

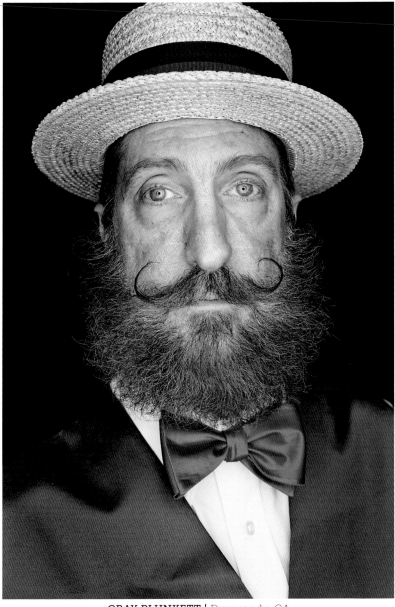

GRAY PLUNKETT | Dunwoody, GA

BENJAMIN JUERGENS Los Angeles, CA
IMPERIAL MOUSTACHE | 1ST PLACE WINNER

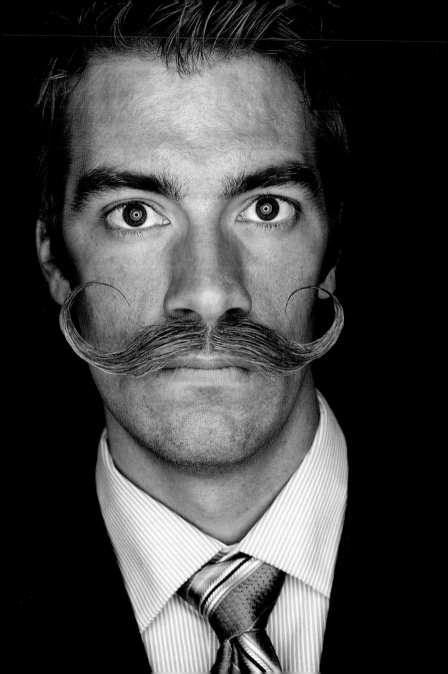

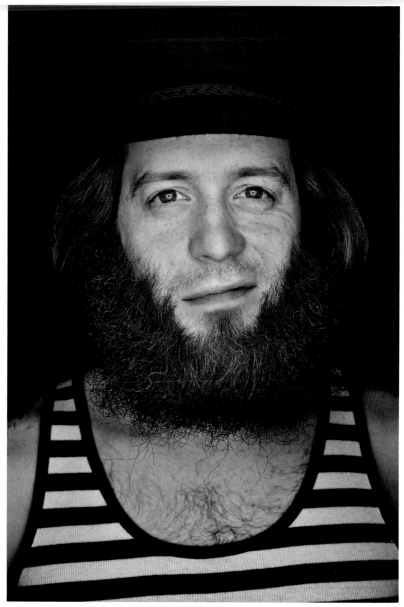

ZACHARY NORTON | Livonia, MI

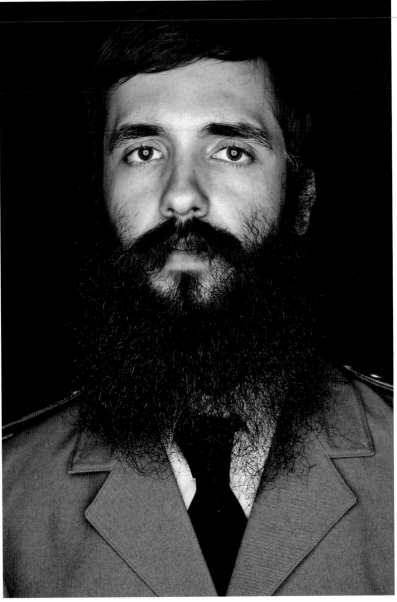

MIKE DUTKEWYCH | Riverview, MI

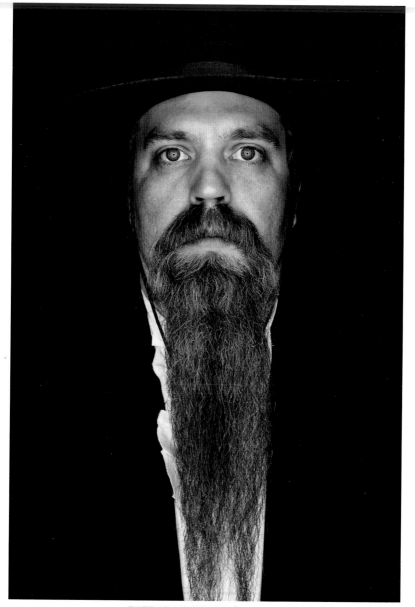

PATRICK DAWSON | Roy, WA

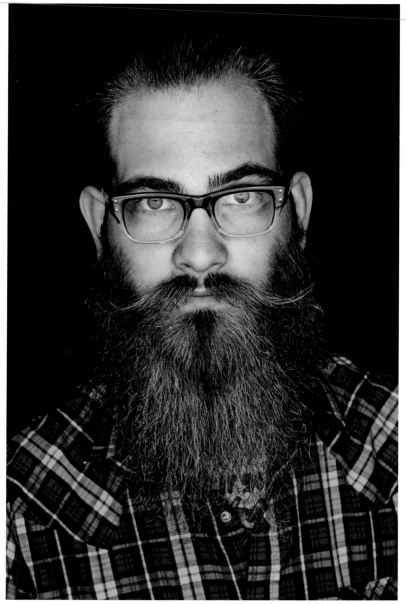

KRIS PAYNE | Brooklyn, NY

ALEXANDER "CONQUISTADOR" ANTEBI
Los Angeles, CA
IMPERIAL MOUSTACHE | 3RD PLACE WINNER

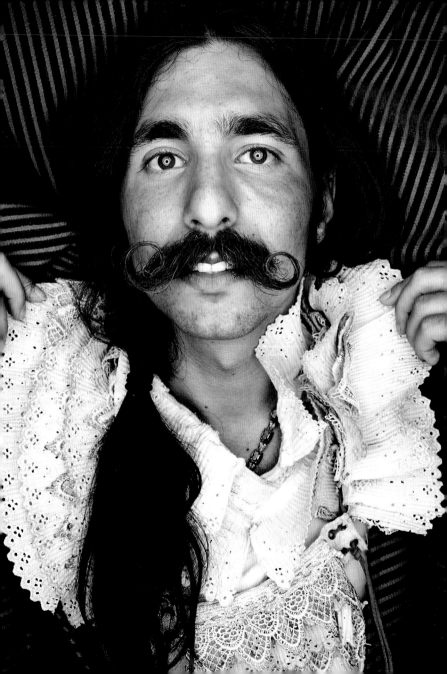

TO THE LAST WHISKER

—— ALEXANDER "CONQUISTADOR" ANTEBI ——

A MOUSTACHE IS AN EXTENSION AND CELEBRATION OF
one's manhood and individual identity. Like a fingerprint, no
two moustaches are alike. It is not something that you are born
with, but something that must be cultivated. So growing into
one's true 'stache is a combination of listening to one's body,
working within the options, and then finding a style that suits
one's face and character.

Should we choose to use it articulately and well, personal adorn-
ment is a mode of communication and form of expression. Like
the Zazous, bebopping kids in Nazi-occupied Paris during World
War II who used fashion and facial hair to fight the Vichy regime,
I use my moustache to rebel without noise or words.

While traveling through the Middle East, I encountered
people who did not have a lot of exposure to outside cultures.
Their views on gender identity were quite cut-and-dry. Facial
hair is masculine (obviously) and long hair is feminine. Seeing
a man with such a stiff upper-lip appendage and extremely long
hair puzzled and fascinated children and adults alike. I felt like
Matthew Broderick in *War Games* when he challenged a super
computer to play a game of tic-tac-toe against itself and it over-
loaded, as a stalemate was outside of its understanding.

The modern world is one that is obsessed with youth and the
concept of male: ideal aesthetic beauty is not one of a man, but
a boy. It is great to be young, but it is also a special thing to reach

manhood. It is something that should be embraced, not denied or to be ashamed of. Like rings on a tree, my moustache is a badge of experience and something I wear with pride. When I am on stage performing, you don't see some fresh face singing about a life not yet lived. You see Conquistador, a dandified, follicle-y, well-endowed man of experience from another time, plane, and universe.

Don't go shaving, fellas.

Sincerely yours to the last whisker,

Conquistador

KARL-HEINZ HILLE Berlin, Germany

IMPERIAL PARTIAL BEARD | 1ST PLACE WINNER
2ND PLACE OVERALL WINNER

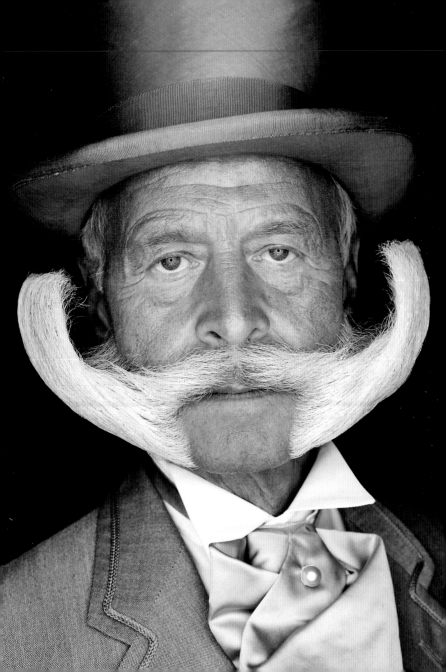